ALL YOU NEED IS A BALLPOINT PEN!

In this book, you'll find easy-to-draw cartoony versions of all your favorite *MHA* characters, giving you yet another way to have a blast with this w

MY HERO ACADEMIA

THE OFFICIAL EASY ILLUSTRATION GUIDE

Original Series by
KOHEI HORIKOSHI

Illustrations by
MIKA FUJISAWA

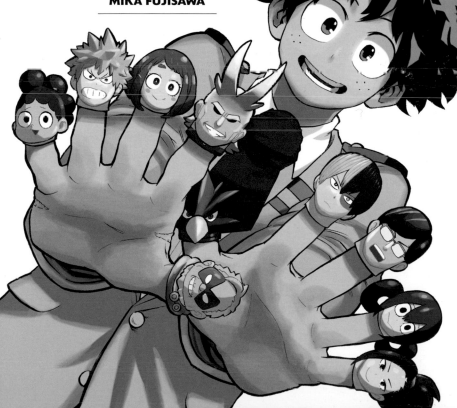

CONTENTS

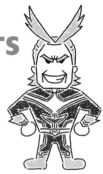

④ HOW TO USE THIS BOOK

CHAPTER 1 Drawing the Characters

CHAPTER 2　Mix-and-Match Combos

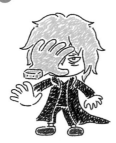 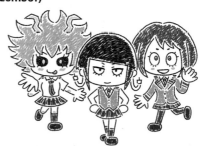

CHAPTER 3　Sketches for Inspiration

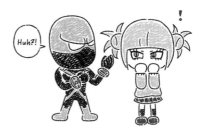

Huh?!

FEEL FREE TO COME UP WITH YOUR OWN POSES AND EXPRESSIONS FOR THE CHARACTERS!

HOW TO USE THIS BOOK

ALL ABOUT BALLPOINT PENS

Water Based
Low ink viscosity makes for clean, smooth lines. Great for coloring as well.

Oil Based
Highly waterproof, quick to dry, and colors don't fade easily. The ink also won't bleed through the paper or smear that much.

Gel
Combines the water-based pen's ease of use with the oil-based pen's tendency not to bleed.

Erasable
Special erasers that use the heat from friction to turn the ink clear and invisible to the eye.

Dye-Based Ink
Allows you to draw on black paper or even photographs. Waterproof, and notable for its vivid colors.

M Ink
Cutting-edge M ink can be used on glass, metal, and even plastic surfaces.

There are all sorts of ballpoint pens out there, so go ahead and choose your favorite. Remember, the colors used in this book are just suggestions!

HOW TO DRAW THE DRAWINGS

Follow the steps for each character from start to finish. Practice is key. Also, the exact order for drawing body parts is just a recommendation, so go about it in whatever way is easiest for you!

HOT TIPS

❶ Draw small, slowly, and steadily
It's easy to mess up proportions when doing big drawings, so start small until you're really used to it. Do sweat the details, but don't get impatient. Slow and steady is the way to go.

❷ Keep your pen tip clean!
Crusty, gunky ink buildup in your pen tip can lead to messy lines that bleed, so be sure to clean your pen often!

❸ Stay in the lines, and then some
When coloring, rather than filling in the shape right up to the outline, consider leaving a little gap, as this often looks better!

❹ Draw disconnected outlines
It's harder to mess up when you purposely don't connect all the parts of the outline.

FEEL FREE TO COME UP WITH YOUR OWN POSES AND EXPRESSIONS FOR THE CHARACTERS!

DIVE INTO THE WORLD OF EASY ILLUSTRATIONS WITH THAT

PLUS ULTRA!! SPIRIT!

1

DRAWING THE CHARACTERS

chapter

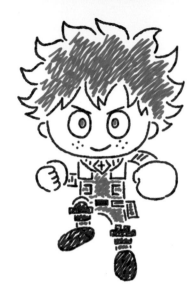

DEKU
IZUKU MIDORIYA

Quirk One For All

A Quirk that passes itself on to someone else. Also comes with the inherited abilities of former users.

This Quirkless boy inherited All Might's own Quirk and now trains so that he can one day face off against the ultimate evil. There's something awe-inspiring about that look on Midoriya's face that screams "I can do this!"

ALL ABOUT THE EYES

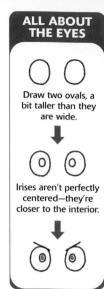

Draw two ovals, a bit taller than they are wide.

Irises aren't perfectly centered—they're closer to the interior.

DRAWING THE FACE

Start with jawline and ears.

Add his largish eyes.

Next, freckles and mouth.

Bangs are longest in the middle. Add the opposite-facing tufts in the top right.

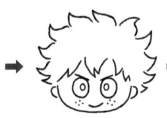

Play around with his naturally floofy hair and try to have the tufts pointing every which way.

Color his irises and hair green.

EXPRESSIONS

Smiling

Anxious

Crying

DRAWING THE BODY

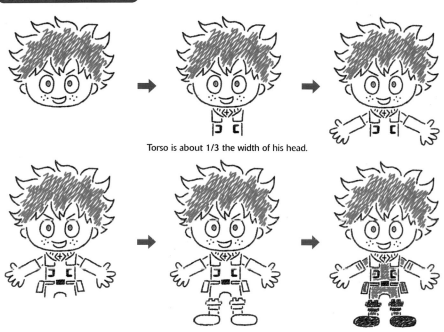

Torso is about 1/3 the width of his head.

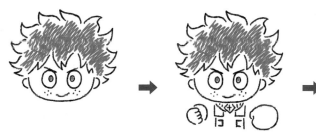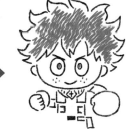

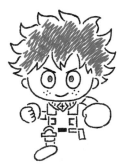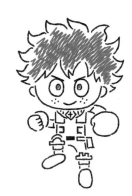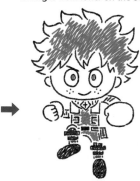

Draw his left hand (on your right) as a fist, bigger than his right.

His raised left arm comes from his shoulder, while his right arm emerges from lower on the body.

For his raised right leg, draw the knee above his waist.

**GREAT EXPLOSION
MURDER GOD: DYNAMIGHT**

KATSUKI BAKUGO

Quirk Explosion

Causes explosions via the nitroglycerin-like fluid that seeps from the sweat glands on his palms.

Since his personality is as volatile as his Quirk, be sure to give his hair some extra oomph. Bakugo has a detailed costume, so take your time drawing each and every little part.

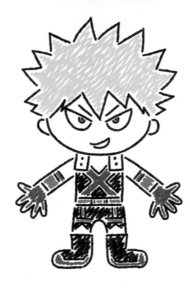

ALL ABOUT THE EYES

He's got angry eyes that slope inward, with red irises closer to the center line.

DRAWING THE FACE

Raise one side of his mouth into a smirk befitting a winner.

One sharp lock of hair in the very middle.

Hair is a series of spikes, and his whorl starts at the tip-top of his head.

More short, stumpy spikes going all the way around.

Hair is a sandy yellow, and irises are red.

EXPRESSIONS

Rage

"Hmph!"

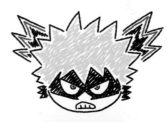

IN COSTUME

DRAWING THE BODY

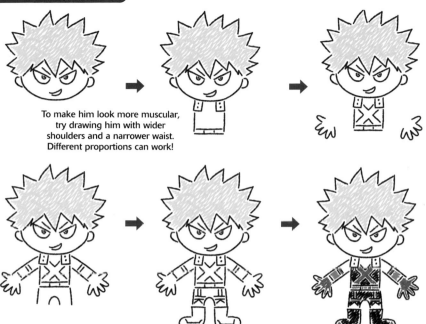

To make him look more muscular, try drawing him with wider shoulders and a narrower waist. Different proportions can work!

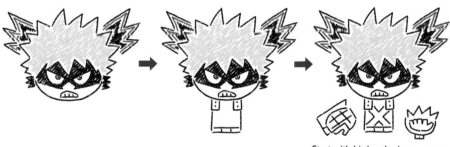

Start with his hands, drawn some distance away from his torso.

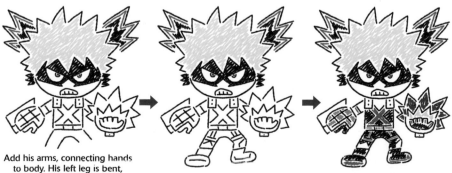

Add his arms, connecting hands to body. His left leg is bent, so draw that one shorter.



SHOTO

SHOTO TODOROKI

Quirk Half-Cold Half-Hot

Freezes with his right half and burns with his left. A powerful ability for close-combat, ranged attacking, and defending.

His icy right half is white and light blue, while his fiery left half is all about the red. Todoroki is a prodigy who brings a cool head and red-hot passion to the table, so make him look fittingly slick.

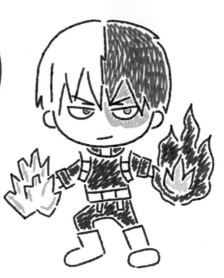

ALL ABOUT THE EYES

Angled slightly inward. His right iris is gray, while his left iris is cyan.

DRAWING THE FACE

His bangs in the very center mark the left-right color divide.

Smooth and silky hair…

Lightly add the outline of his burn scar under his left eye.

Hair on his left half is red. Color in the scar or leave it as just an outline.

EXPRESSIONS

"Hmm?"

Angry

At Peace

DRAWING THE BODY

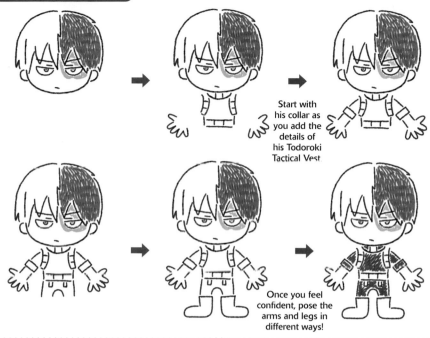

Start with his collar as you add the details of his Todoroki Tactical Vest

Once you feel confident, pose the arms and legs in different ways!

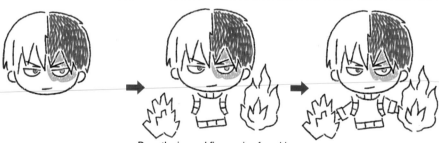

Draw the ice and fire coming from his hands first. Use jagged, straight lines for the ice, and wavy, wobbly lines for the fire.

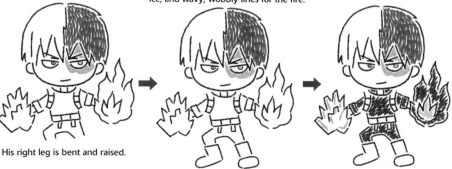

His right leg is bent and raised.

Light-blue highlights give texture to the ice, while yellow and red work well for the fire.

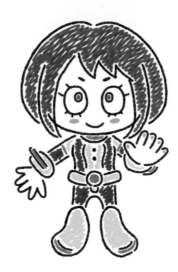

Though she comes across as being a softy, Uraraka's got a powerful core. So after drawing those soft, rounded lines, you can portray that inner strength by changing up her expression.

ALL ABOUT THE EYES

Her brown irises go in the inner-upper section of her oval eyes. Then, long eyelashes on top, short ones on the bottom. Her eyebrows are short and kind of thick.

DRAWING THE FACE

Eyes should be nice and big.

Those locks of hair on the side should be pretty long.

The hair farther back should be shorter than those sidelocks and should create her rounded silhouette.

Add pink dots on her cheeks, and color her irises and hair chestnut brown.

EXPRESSIONS

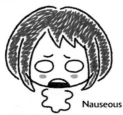

Nauseous

Smiling

IN COSTUME

DRAWING THE BODY

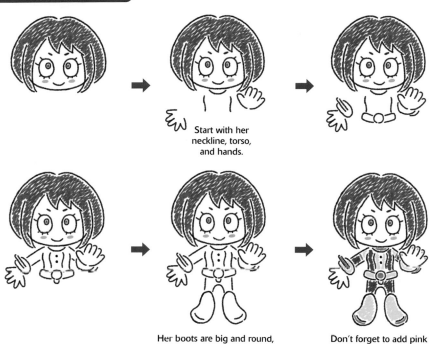

Start with her neckline, torso, and hands.

Her boots are big and round, like plump lima beans.

Don't forget to add pink for her finger pads!

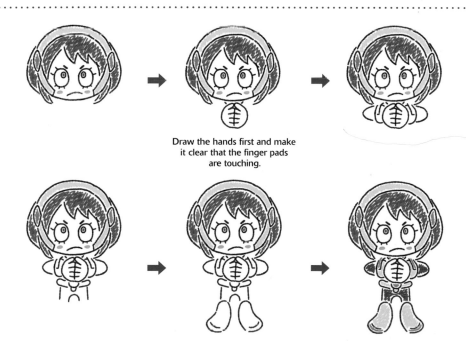

Draw the hands first and make it clear that the finger pads are touching.

INGENIUM
TENYA IDA

Quirk Engine

The engine-like devices in his calves make him remarkably fleet of foot. That speed allows for powerful attacks.

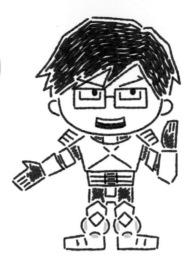

This straight-edge four-eyes treasures his friends and takes his responsibilities super seriously. Drawing him with lots of straight, clean lines will bring out the essence of Ida.

ALL ABOUT THE EYES

Rectangular eyes within rectangular eyeglass frames. His eyebrows go on the diagonal, with those distinctive flicked-up tips.

DRAWING THE FACE

Begin with his glasses and jawline.

His mouth is a rectangle that's been curved up a little.

Start with the bangs in the very middle, then add bits on each side.

That 70:30 hair part makes for a very serious and professional look.

His hair is a deep blue, almost dark gray.

EXPRESSIONS

Surprised

Thinking Hard

IN COSTUME

DRAWING THE BODY

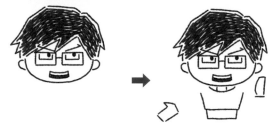

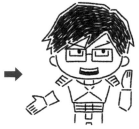

Even his hands are made of mostly straight lines.

His fingers are all held together, implying that robotic movement.

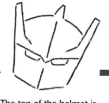

For Ida's Ingenimet, the jaw outline comes to a slight point. After that, add the brow line and the central dividing line.

The top of the helmet is rounded, with a pointy ridge in the middle. Next, draw his eyes.

Fill in some details.

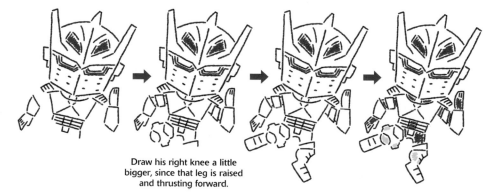

Draw his right knee a little bigger, since that leg is raised and thrusting forward.

FROPPY
TSUYU ASUI
Quirk Frog

Gives her frog-like abilities, such as a long, stretchy tongue and hands and feet with suction properties. She can even use camouflage to blend in with her surroundings.

Asui's sticky tongue can stretch up to twenty meters, so you can draw it as long and wiggly as you like!

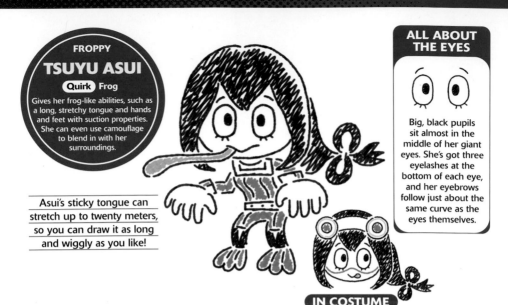

IN COSTUME

ALL ABOUT THE EYES

Big, black pupils sit almost in the middle of her giant eyes. She's got three eyelashes at the bottom of each eye, and her eyebrows follow just about the same curve as the eyes themselves.

DRAWING THE BODY

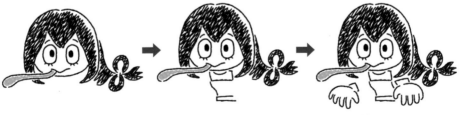

Start with her distinctive eyes, mouth, and long tongue! Draw this even before her jawline.

Next comes a thick lock of bangs, smack-dab in the middle.

Her sidelocks form a giant M with the bangs in the middle. The hair in the back is tied into a figure eight, almost like a ribbon.

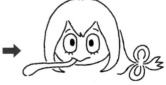

Her hands are bigger than most people's.

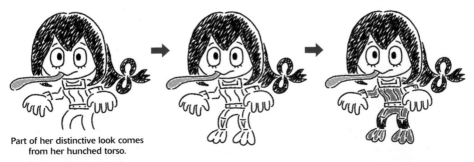

Part of her distinctive look comes from her hunched torso.

ALL ABOUT THE EYES

His eyes slope inward. Don't forget the scar over his right eye! His eyebrows are close to the middle and pretty short, and his irises are bright red.

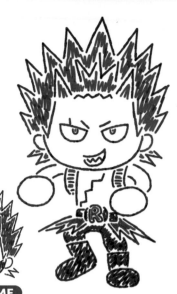

RED RIOT

EIJIRO KIRISHIMA

Quirk Hardening

Turns his entire body hard and craggy. The sharp edges are great for both defense and slashing attacks.

His trademark red hair is just a series of pointy spikes. Given that Kirishima's Quirk makes his whole body harden up, you want it to look like even his hair is rock-hard.

IN COSTUME

DRAWING THE BODY

Note the sharp teeth. For his hair, start with the bangs that are flipped up to look like horns.

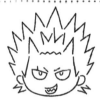

Go big and bold with his spiky hair!

Irises and hair should be red.

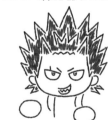

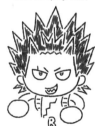

Draw a bubble letter R on his belly.

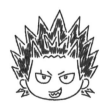

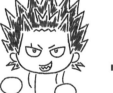

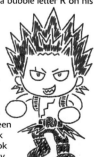

For his shoulder armor, switch between maroon and black lines to make it look rugged and bumpy.

MY HERO ACADEMIA – DRAWING THE CHARACTERS **17**

CREATI

MOMO YAOYOROZU

Quirk Creation

Can create any nonliving thing.

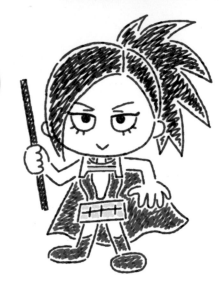

Only a mind as sharp as Yaoyorozu's could comprehend the molecular structures of different objects, allowing her to use her power. Her sharp expression suggests how talented and on the ball she is.

ALL ABOUT THE EYES

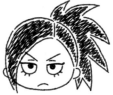

The outer corners are slightly thicker and flipped up. Her long, thin eyebrows should slope down gently.

EXPRESSION

DRAWING THE BODY

 →

This classy lady has a small mouth.

→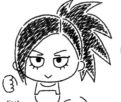

Draw her ponytail off to one side, nice and big and spiky.

 →

Make her waist a little thinner, to show off her physique.

 →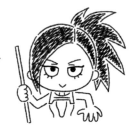

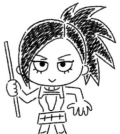 → →

His eyes resemble pointy isosceles triangles. They should slope inward to the extreme.

EXPRESSION

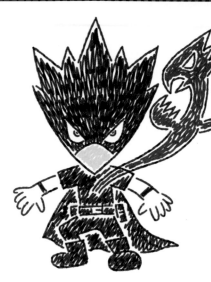

TSUKUYOMI
FUMIKAGE TOKOYAMI

Quirk Dark Shadow

He controls a shadowy beast dwelling within his body—one that grows more powerful and violent in the dark.

Tokoyami's main color is black, and his and Dark Shadow's eyes come to sharp points at the corners.

DRAWING THE BODY

Draw his beak facing forward with a bold, pointed outline.

Color his irises red.

When drawing Dark Shadow's face, be sure to leave enough room for its body.

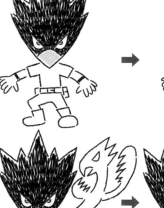

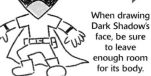

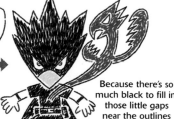

Because there's so much black to fill in, those little gaps near the outlines are that much more important.

GRAPE JUICE

MINORU MINETA

Quirk Pop Off

He can rip extraordinarily sticky balls from his head. The balls can be used to stop enemies in their tracks or to help Mineta climb up walls.

As you might guess from his hero name, Mineta's head should look like a bunch of grapes.

ALL ABOUT THE EYES

Big eyes, with droopy eyebrows that connect to his eyes at the bottom.

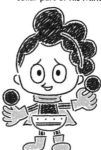

IN COSTUME

DRAWING THE BODY

The outline of his "hair" follows that repeating bubbly pattern.

His torso is narrower than the collar part of his Minoru Cape.

Draw the Grape Pants extra big, especially compared to his skinny arms.

The cape should be short, and his boots are chunky and cartoony!

ALL ABOUT THE EYES

Eyebrows are short, inward sloping, and close to the middle.

IN COSTUME

If you want to fill in his sunglasses with blue, add the blue first, and then draw his eyes on top.

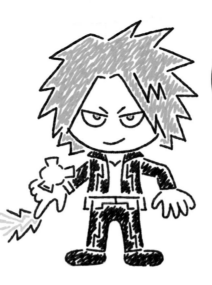

CHARGEBOLT

DENKI KAMINARI

Quirk Electrification

He can modify his wattage and even use it to recharge phones. His weakness? Releasing too much turns him into an idiot…

After launching a target from his shooter gauntlet, he can release a zap of electricity from his fingertip with pinpoint precision! Drawing the lightning bolt at just the right size can show how much power he's using.

DRAWING THE BODY

His bangs part a little to the left of center. The bottom tip of his mouth should flip up in a smirk.

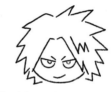

Don't forget that all-important lightning-bolt pattern in his hair!

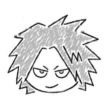

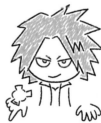

Draw his hands and shooter before his arms.

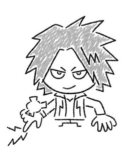

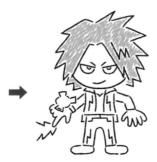

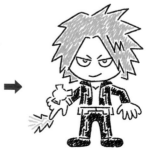

Add extra yellow lines inside the little lightning bolt.

EARPHONE JACK
KYOKA JIRO

Quirk Earphone Jack

The plugs on her earlobes can amplify her heartbeat into attacks. Sticking the plugs into walls lets her eavesdrop.

The boots are key, since they're support items that aid her power. Make them big and bulky to show how much of a rocker Jiro is!

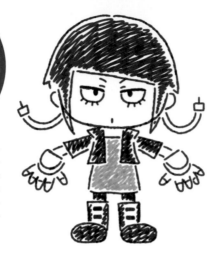

ALL ABOUT THE EYES

She's got big eyes with relatively small pupils. Her short eyebrows slope inward, and the upper edge of each eye should be a thick line.

IN COSTUME

DRAWING THE BODY

 ➡️ ➡️

Her bangs slope down to the right, and her sidelocks are fairly long.

The overall hairstyle is a short, rounded bob cut.

 ➡️ ➡️

Draw her earlobes as long cords with plugs on each end.

Add her amplifier items before her actual hands.

 ➡️ ➡️

ALL ABOUT THE EYES

He's got black pupils almost in the very middle of his diamond-shaped eyes. His eyebrows should be at the same angle as the inner lines of his eyes.

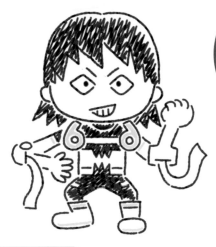

CELLOPHANE
HANTA SERO
Quirk Tape

Launches tape from his elbows. Diverse applications include tying up enemies, laying traps, maneuvering around obstacles, and swinging from high places.

Sero's tricky techniques turn the tables on villains, but he's also great at livening up the class, so that smug grin of his is key when drawing him.

IN COSTUME (WITH HELMET)

DRAWING THE BODY

His smile shows off his teeth!

Make his hair come to spiky points at the ends.

The armor on his right shoulder looks like a bubble letter 6, while the one on his left is a mirror image of that.

Drawing one of his tape-dispenser elbows larger than the other makes it look like it's jutting forward.

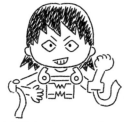

Add his hands, arms, and torso.

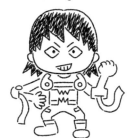

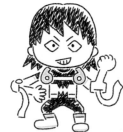

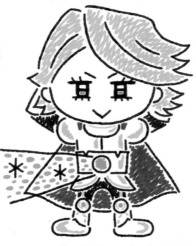

CAN'T STOP TWINKLING
YUGA AOYAMA

Quirk Navel Laser

Fires a long-range laser from his belly button. Using it for more than one second makes his stomach hurt.

His sparkly eyes are competing to look just as fabulous as his navel laser. When drawing him, imagine that Aoyama is a character from a shojo manga series.

ALL ABOUT THE EYES

Draw each eye as a rectangle with another thick line through the middle. His upper and lower eyelid lines should extend beyond the eyes themselves. Don't forget the long eyelashes.

IN COSTUME

Either fill in the red of his Sparkly Glasses after drawing the eyes, or apply the red first and draw the black eyes on top afterward.

DRAWING THE BODY

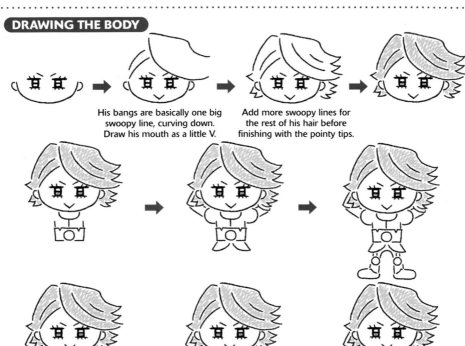

His bangs are basically one big swoopy line, curving down. Draw his mouth as a little V.

Add more swoopy lines for the rest of his hair before finishing with the pointy tips.

Make the navel laser look sparkly by filling it in with squished blue polka dots!

Her eyes are rounded rectangles with raised outer edges. Add big irises inside.

Fill her eyes in with black and give her yellow irises.

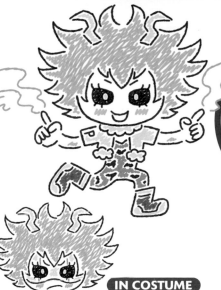

PINKY
MINA ASHIDO

Quirk Acid

Her body secretes acid, which she can shoot. It's useful for melting stuff, attacking enemies, and even defense when it's thick enough.

The sheer energy and cheeriness of this athletic girl can come across through her smile and expressive limbs.

IN COSTUME

DRAWING THE BODY

Her bangs are clumped together right in the middle of her forehead.

When drawing her sidelocks, make sure they're inside the outline of her face.

Her pink hair flips up, like it's practically leaping off her head. Add some pink blush to her cheeks too.

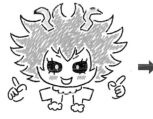

Draw her legs as if she's running and jumping around.

Use wiggly, curvy lines for the acid shooting from her fingertips, and get as creative as you want with the shape of each blob.

TENTACOLE
MEZO SHOJI

Quirk Dupli-Arms

The tentacles on his shoulders can duplicate his body parts. Extra eyes and ears are handy for scouting, while extra arms boost his attack power.

A single eye is the only part of Shoji's face that's visible, so try to imply different expressions based on the position of that one pupil. Have fun with his dupli-arm tentacles, which can also transform into extra mouths, ears, and other parts.

A single almond-shaped eye emerges from under his bangs. The pupil is small.

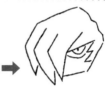

EXPRESSION

DRAWING THE BODY

An angular lock of hair extends past his eye.

Divide his bangs into those three pieces.

The top left line of his hair can be parallel to the line above his eye. Meanwhile, draw the points of his sidelocks pointing toward his face.

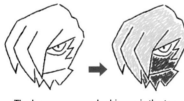

The larger curve under his eye is the top of his mask, and the bottom edge of the mask goes as low as his collarbone.

Give him three fists on each side of his body.

Draw his body first, then arms connecting each fist to his torso.

ALL ABOUT THE EYES

Draw two pairs of slanting lines, spaced a bit apart, and add two pupils a smidge past the midpoint of each line, giving him a clean and sharp expression.

EXPRESSION

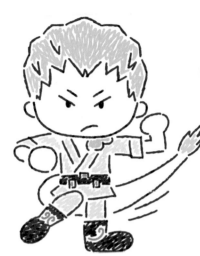

TAILMAN

MASHIRAO OJIRO

Quirk Tail

His durable tail is suited to martial arts attacks, as it can be wielded like an extra arm.

Ojiro is a powerful fighter whose weapons are his tail and entire body, so drawing him in action poses is the best way to portray his strength!

· ·

DRAWING THE BODY

 ➡ ➡

His hair seems to flow forward, from the back. The spiky tufts of his bangs point toward the center.

 ➡ 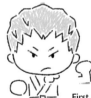 ➡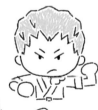

First draw his right leg, which is jutting forward. It should be at a diagonal, like he's about to throw a roundhouse kick.

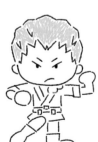 ➡ ➡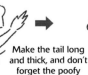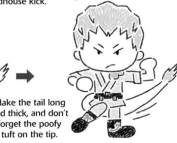

Make the tail long and thick, and don't forget the poofy tuft on the tip.

(FLASH)

Since her face and body are invisible, try to portray Hagakure's mood and expression via the position and pose of her hands, the angle of her boots, or even a written-out sound effect!

EXPRESSION

DRAWING THE BODY

Start with the wrists, then add the hands.

When putting space between her hands, try to imagine her invisible body.

Similarly, imagine a pair of legs while drawing her boots.

(FLASH)

Those thick eyebrows are distinctive. Draw his small pupils closer to the center line.

SUGARMAN

RIKIDO SATO

Quirk Sugar Rush

Consuming ten grams of sugar makes this brawny bruiser five times stronger for three minutes.

The wrestler costume is fitting, given Sato's power-up Quirk. Making his upper body bigger than his lower body is key.

IN COSTUME

DRAWING THE BODY

 ➡ ➡

Be sure to include Sato's thick lips, and make his hairline a series of little ripples.

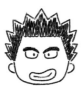 ➡ ➡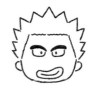

Imagine his body as an upside-down triangle as you draw his sides, from armpit to waist. You want to imply those bulging muscles!

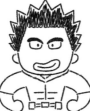 ➡ ➡

The curve from shoulder to hand is basically a half circle, ending down around his waist.

ANIMA
KOJI KODA
Quirk Anivoice

He can control animals with his voice. His power works not only on birds and mammals, but also on insects.

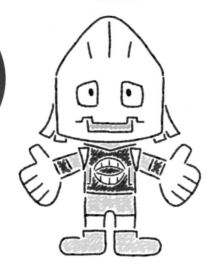

Koda loves animals and nature, and an aura of warmth and friendliness emanates from the kindly "Petting Hero." To show that, be sure to add gentle curves to his otherwise angular body.

ALL ABOUT THE EYES

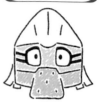

The tops of his mostly square eyes should droop down, getting across those friendly vibes.

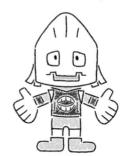

IN COSTUME

DRAWING THE BODY

Draw his jawline like the bottom of a cylinder.

Imagine a little mountain peak as you draw his head.

Fluttery flaps of hair stick out on either side of his jaw.

Show off his big, broad palms.

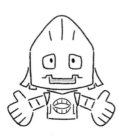 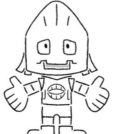

Small pupils sit inside his big, angry-looking eyes. Jagged shapes surround each eye, divided by a single thick line shooting out to the side from the lower corner of the eye.

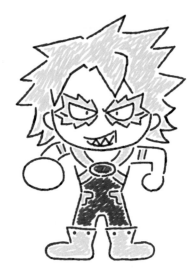

IN COSTUME

REAL STEEL
TETSUTETSU TETSUTETSU
Quirk Steel

Turns his whole body into metal. The more iron in his diet, the tougher he gets and the longer the effect lasts.

You'll want to make Tetsutetsu's pointy parts look especially sharp to demonstrate how tough and solid his body is!

DRAWING THE BODY

Give him sharp teeth.

His hair is grouped into thick, spiky bundles.

Draw an oval in the center of his chest. His right fist can be nice and big, since he's punching forward.

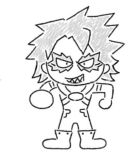

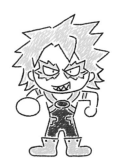

NEITO MONOMA

Quirk Copy

Copies the Quirk of anyone he touches. He can keep up to four different copied Quirks but can only use one at a time, for up to five minutes.

Monoma selects the optimal copied power to use against the enemy, and he's also a smooth talker who can attack opponents with his words. Note the blank expression, almost like he's playing dumb.

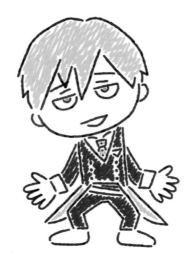

ALL ABOUT THE EYES

Give him half-moon eyes with half-moon irises. Put an extra pair of little lines between his eyes and eyebrows to imply upper eyelids.

EXPRESSION

DRAWING THE BODY

Make his jawline curve up to the right.

His eyes should be at the same tilt as his jawline.

Draw his hands sticking out on either side of his torso.

Having his legs bowed out like that makes him look tired and almost bored.

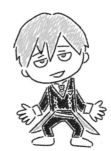

ALL ABOUT THE EYES

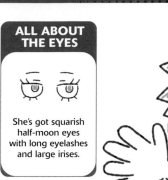

She's got squarish half-moon eyes with long eyelashes and large irises.

IN COSTUME

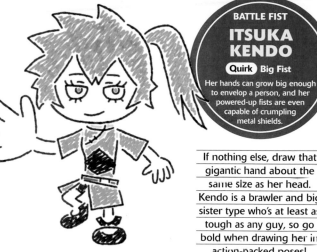

BATTLE FIST

ITSUKA KENDO

Quirk Big Fist

Her hands can grow big enough to envelop a person, and her powered-up fists are even capable of crumpling metal shields.

If nothing else, draw that gigantic hand about the same size as her head. Kendo is a brawler and big sister type who's at least as tough as any guy, so go bold when drawing her in action-packed poses!

DRAWING THE BODY

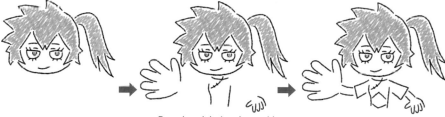

Have one long tuft of hair flopping down over her forehead.

Start with the hair spikes at the top of her head, and continue down around her right side. Her hair is tied into a ponytail on her left.

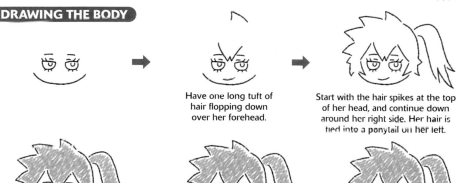

Draw her right hand extra big.

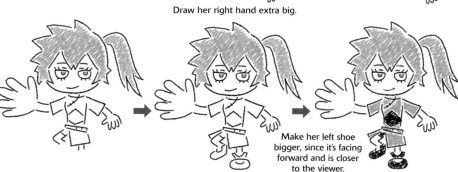

Make her left shoe bigger, since it's facing forward and is closer to the viewer.

Togata's skills helped him make it into U.A.'s Big Three, and people say he's practically good enough to be the number one hero. He should look powerful and imposing in your drawing.

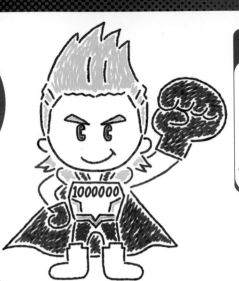

ALL ABOUT THE EYES

Draw a pair of ovals with a little square chunk taken out of one side. His eyebrows are basically isosceles triangles.

IN COSTUME

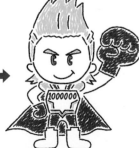

DRAWING THE BODY

 ➡ ➡

His hairstyle is all about that verticality.

 ➡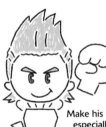

Make his raised fist especially big to help him show off his powerrrr!

➡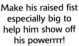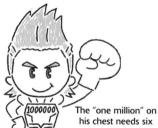

The "one million" on his chest needs six zeros, so be sure to leave enough room to keep them balanced!

 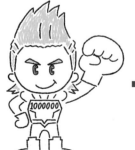 ➡ 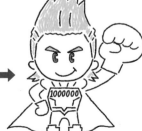 ➡

Give him long, thin almond-shaped eyes, with eyebrows about half as long. His upper eyelids should curve down toward the inner corners of his eyes.

IN COSTUME

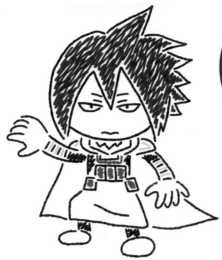

SUNEATER
TAMAKI AMAJIKI

Quirk Manifest

He can manifest the physical traits of whatever he eats. Poisons and venoms are possible too, as long as they come from living things.

Amajiki can control where on his body the food part emerges from, and even how big it'll be. Once you've gotten used to drawing his basic body, have fun trying different arrangements of food and animal parts.

DRAWING THE BODY

Draw one big tuft of bangs right in the middle, and frame his face with long, curved sidelocks.

Start with the hair spike on top, then follow up with the rest of the spikes, which should point backward and be a bit staggered.

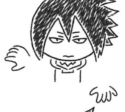

Try to make his negativity come across by giving him a small pursed mouth!

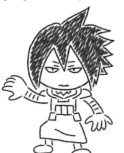

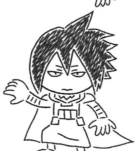

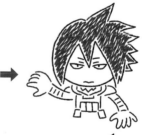

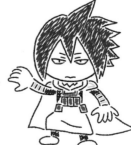

NEJIRE HADO

Quirk Surge

Turns her own dynamic energy into shootable shock waves.

She can adjust the spiraling nature of her Quirk's energy waves to create powerful attacks. The swirly strands of hair on top of Hado's head symbolize her spiral-based power.

ALL ABOUT THE EYES

Be sure to draw her eyes quite big, with thick black lines to represent her upper eyelids.

IN COSTUME

DRAWING THE BODY

Make her sidelocks flip inward toward her face.

Her hair is so voluminous that it looks like it could wrap up her whole body.

Add the swirly pair of hairs on top of her head.

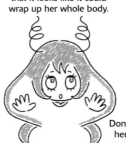

Don't color in all her hair, since you still need to draw her body in the middle.

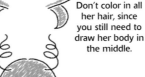

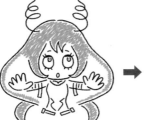

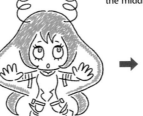

By drawing her knees pointing inward, you can make it look like she's floating in the air!

ALL ABOUT THE EYES

The bottom outline of his eyes should be extra thick and dark. Draw his eyebrows high up so you can fit the upper eyelids in between. His irises are centered, with white pupils.

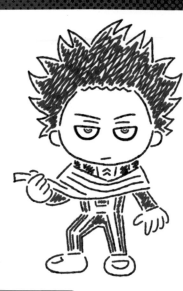

IN COSTUME

? ? ?

HITOSHI SHINSO

Quirk Brainwashing

If his target responds to him verbally, the brainwashing takes hold. After that, they have no choice but to obey Shinso.

Shinso is hoping to transfer from General Studies into the Hero Course, so it's key that his eyes hint at that heroic passion deep within. In addition to his Quirk, he's also equipped with a binding cloth from his mentor, Eraser Head.

DRAWING THE BODY

Show off his whole forehead and draw a little wavy line as his hairline.

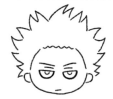

His hair spikes should point in random directions, with every tuft standing on end.

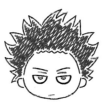

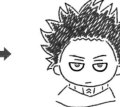

After drawing the boxy outline of the binding cloth, add in the other horizontal lines, but don't make them too messy.

MEI HATSUME

Quirk Zoom

Her super-vision lets her see things clearly from up to five kilometers away.

As a Support Course student who crafts tools and items, Hatsume has got ideas for days, even if some of them end up running amok… Her eager expression shows how ready she is to get to work.

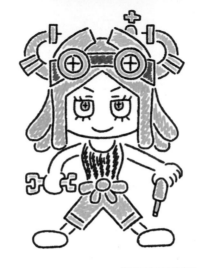

ALL ABOUT THE EYES

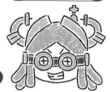

Her eyes should be square on top but round on the bottom. Give her nice, big irises with plus signs in the middle. Those "angry eyebrows" don't mean that she's mad—she's just extra determined to get the job done.

IN COSTUME

DRAWING THE BODY

 ➡ ➡ ➡

The goggles are pretty complex, so start with the simple circular lenses before adding all the crazy details.

Draw her hair as distinct, thick locks with rounded tips.

 ➡ ➡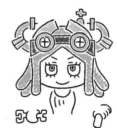

Next comes her torso, and then her hands (holding tools).

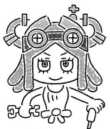 ➡ 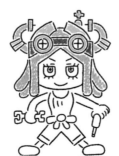 ➡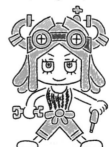

She's got jacket sleeves tied around her waist.

Draw a squished less-than sign (<) to make him wink!

IN COSTUME

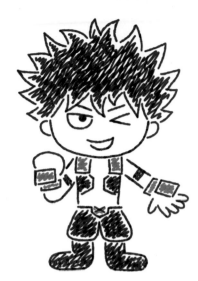

GRAND
YO SHINDO
Quirk Vibrate

He can vibrate anything he touches—an ability strong enough to crack the ground itself. But the blowback leaves him immobilized for a while.

This second-year student from Ketsubutsu Academy is a two-faced schemer and tactician, but he tends to hide that dark side with a handsome smile. Try to master those two sides of Shindo in your drawings.

DRAWING THE BODY

His hair is shorter than Deku's, but just as floofy and full of cowlicks.

Draw his torso, shoulders, and hand protectors.

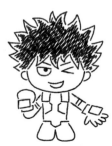

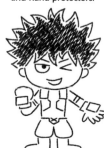

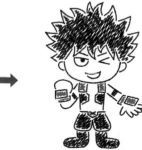

The cuffs of his pants are tucked into the boots, so make the pant legs bulge at the bottom.

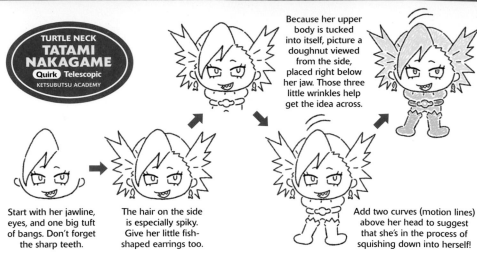

TURTLE NECK
TATAMI NAKAGAME
Quirk Telescopic
KETSUBUTSU ACADEMY

Start with her jawline, eyes, and one big tuft of bangs. Don't forget the sharp teeth.

The hair on the side is especially spiky. Give her little fish-shaped earrings too.

Because her upper body is tucked into itself, picture a doughnut viewed from the side, placed right below her jaw. Those three little wrinkles help get the idea across.

Add two curves (motion lines) above her head to suggest that she's in the process of squishing down into herself!

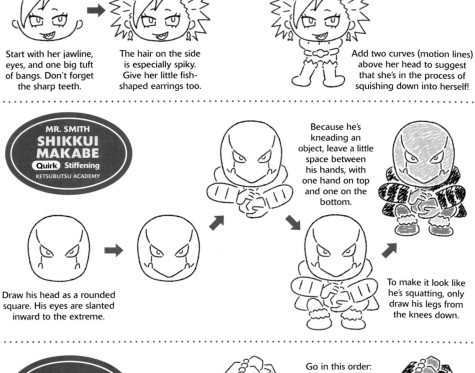

MR. SMITH
SHIKKUI MAKABE
Quirk Stiffening
KETSUBUTSU ACADEMY

Draw his head as a rounded square. His eyes are slanted inward to the extreme.

Because he's kneading an object, leave a little space between his hands, with one hand on top and one on the bottom.

To make it look like he's squatting, only draw his legs from the knees down.

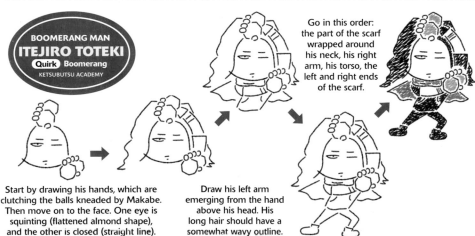

BOOMERANG MAN
ITEJIRO TOTEKI
Quirk Boomerang
KETSUBUTSU ACADEMY

Start by drawing his hands, which are clutching the balls kneaded by Makabe. Then move on to the face. One eye is squinting (flattened almond shape), and the other is closed (straight line).

Draw his left arm emerging from the hand above his head. His long hair should have a somewhat wavy outline.

Go in this order: the part of the scarf wrapped around his neck, his right arm, his torso, the left and right ends of the scarf.

He gets angry-looking eyebrows, and his eyes are sharp triangles. Be sure to draw his goggles just above the brim of his cap.

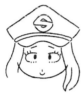

In this step, start with the fluffy fringe around his neck. Then do his left arm (with the big gauntlet), his raised right arm, and his torso.

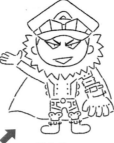

Note the many details on his lower body. Save his cape for last.

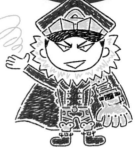

Draw her cap before drawing her face. Her eyes are like a C and a backward C, with pupils right at the inner edges. Make her lips look plump by adding that extra curve at the bottom.

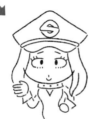

Since she's blowing a kiss, draw her raised right hand slightly bigger.

Bend her left leg in front of her straight right leg to create that fancy pose!

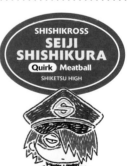

After drawing his cap, give him big floppy bangs that cover a good chunk of his face. Then comes his eye mask, revealing one thin eye.

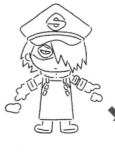

His torso is framed by two perfectly straight lines. Include some chunks of disembodied flesh emerging from his deformed hands.

ERI

Quirk Rewind

The ability to rewind living things to previous states. Little is known or understood about this power.

Eri and her Quirk were once exploited by a yakuza gang, but Deku and the raid team saved her from that horrible life. The horn on her forehead is where her power comes from. Draw it diagonally.

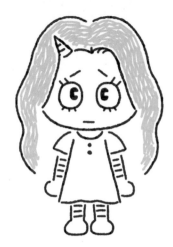

Big eyes, with long eyelashes. Her irises are tall ovals with square chunks taken out of them.

EXPRESSION

DRAWING THE BODY

Draw her horn, then connect it to her jawline with one side of her hair.

Her eyes should be about halfway down her face to give her a childlike look.

 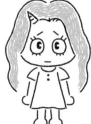

When drawing her body, make it smaller than other (more grown-up) characters' bodies.

Add little horizontal lines on her arms and legs to represent the wrapped bandages.

ALL ABOUT THE EYES

His eyebrows are thick, curved rectangles, connected in the middle like a bow pointing down. Draw his eyes as solid black shapes pressed right up against his eyebrows. The three wrinkles between his eyebrows are essential.

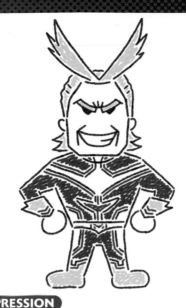

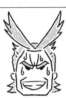

EXPRESSION

He passed on his Quirk to Deku and later retired, but All Might's muscle form will forever symbolize heroism. This form's trademarks are the wide grin and even wider torso.

DRAWING THE BODY

Draw his jawline with straight lines and clear-cut angles.

His eyes should be above his ears. The distinctive hair tufts start with that giant V.

Add a single line within one side of his smiling mouth to imply upper and lower teeth.

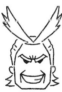

His hairline consists of a barely curved line just under the hair tufts and more straight, angled lines heading toward his ears. Below his ears, add two more hair tufts on each side, pointing backward.

Draw broad shoulders starting right at his jawline. Make him look mighty muscular by using the upside-down triangle method for his torso.

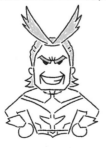

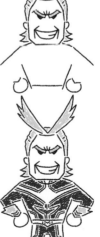

To make the costume colors look especially clean, go in the following order: red, yellow, blue.

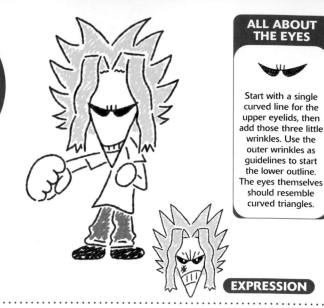

The battle against his fated foe—All For One—saw All Might use up the last of his power, leading to his retirement. In this form, his head is a skinny upside-down triangle with a sharp point for the chin.

ALL ABOUT THE EYES

Start with a single curved line for the upper eyelids, then add those three little wrinkles. Use the outer wrinkles as guidelines to start the lower outline. The eyes themselves should resemble curved triangles.

EXPRESSION

DRAWING THE BODY

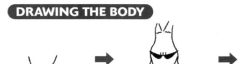

It all begins with the big V of the jawline.

His eyes are placed just above the V, and directly above them, at the top of the forehead, is his hairline.

Slightly above the hairline, draw the two tufts of hair, which look like wavy ribbons. Imagine that the V-shaped tufts from his muscle form got droopy and flopped down in front.

The hair spikes on both sides—all of them pointing up and out—come together at the top of his head in the very middle, where his hair parts.

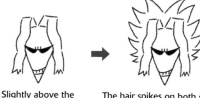

Draw the extended right fist extra big. The left fist should be smaller, near his chin.

His left shoulder starts around the same height as his mouth. His T-shirt will be a triangle (not an upside-down one) that begins at the tip of his chin.

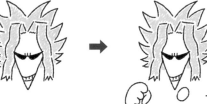

Add his arms, connecting his hands to his torso.

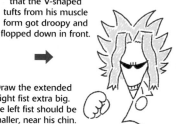

Draw his pants with wobbly, wavy lines at the bottom to make them look baggy around his ankles.

Make the upper outline of the eyes flip up at the inner corners to show how intimidating he is. The irises should rest against the upper eyelid. Give him three wrinkle lines in the center of his brow.

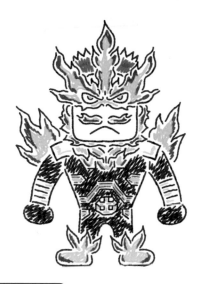

PRO HERO
ENDEAVOR
Quirk Hellflame

He can use the roaring flames that wreathe his body to roast his enemies with fiery attacks or even to move through the air at high speed.

The current number one hero uses his duty and obligation as a guiding light, facing down evil as a new pillar of heroism protects people! Go big, bold, and wild when drawing the flames, as they're the best way to emphasize Endeavor's strength.

EXPRESSION

DRAWING THE BODY

 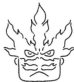 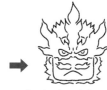

Imagine his jawline as a square with rounded corners, ending at his ears. Place his eyes higher than his ears.

Five plumes of fire surround his eyes. Draw the three on top with wavy lines for that fiery effect.

Draw a flaming beard close to his jawline, and add his cropped, spiky hair on top, between the fire plumes

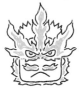

The center of each fire plume can be colored with yellow or orange.

Add bits of red to the outer edge of the fire. Adding the red more randomly can give that shimmery, wavy look to the fire.

Use an upside-down triangle for his torso, creating wide shoulders.

Draw more plumes of fire shooting from his shoulders.

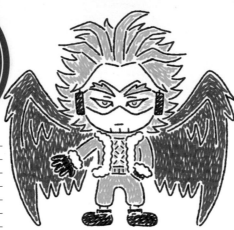

The wings granted to Hawks by his Quirk should be drawn symmetrically on either side of his body. The feathers are longest at the outer edge and grow shorter as you move inward.

ALL ABOUT THE EYES

His eyes slope inward and have tiny black triangles at the inner and outer corners. The triangles at the inner corners point down, and the ones at the outer corners are like extensions of the upper eyelid.

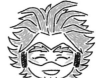

EXPRESSION

DRAWING THE BODY

Start with his jawline, then add the ear protectors.

Draw his goggles butting up against the ear protectors. Give him about five tufts of ribbony hair as bangs, pointing up and fanning out. Three little lines on his chin form his goatee.

 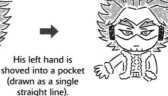

His left hand is shoved into a pocket (drawn as a single straight line).

 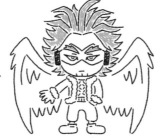 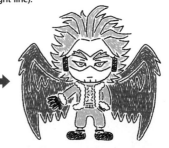

Finish his body before starting on the wings. Begin with the bottom feathers on the inside.

To imply that his goggles are see-through, don't fill them in completely with yellow—just add some yellow at the outer edges.

ALL ABOUT THE EYES

Draw that one eye peeking out from under the diagonal bangs and give him three short eyelashes.

EXPRESSION

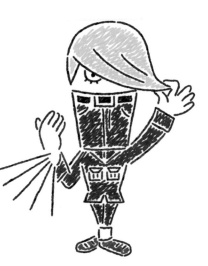

PRO HERO

BEST JEANIST

Quirk Fiber Master

Allows him to control fibers (from clothing or other materials). Good for attacking and binding villains.

There's nothing this fashion icon can't do with denim. Best Jeanist became a hero with the goal of reforming violent, uncouth individuals, so be sure to make him look especially serious, almost to a silly extent.

- -

DRAWING THE BODY

After the bangs and the eye, the next part to draw is the collar covering up his face.

➡

The full collar resembles a drinking glass. Add the belt, pockets, and other details.

➡

➡

Next come the hands and the torso. His left hand is pinching his hair off to the side.

➡

Connect hands to torso with arms and add strings shooting from his right wrist.

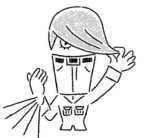

➡

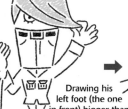

➡

His legs are squeezed together, forming an upside-down triangle. Draw a line in the middle of them to show that the left leg is in front (so you only need to draw the left ankle).

Drawing his left foot (the one in front) bigger than his right will make him pop off the paper more!

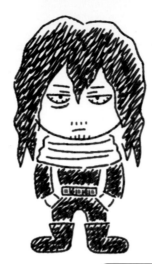

PRO HERO
ERASER HEAD

Quirk Erasure

Anyone he stares at is unable to use their Quirk for the duration. He can take down villains with his special binding cloth.

The class 1-A homeroom teacher lives by the law of rationality and hates wasting time, but he's a pro at looking after his students. Eraser Head's ability requires him to (over)use his eyes, so be sure to make his eyes look exhausted.

IN COSTUME

ALL ABOUT THE EYES

His eyes should have relatively small pupils and little lines around the edges, giving them that bloodshot effect. Note the scar under his right eye.

DRAWING THE BODY

Draw his bangs flopping down between his eyes. Include a bit of stubble above and below his mouth.

Wavy, snakelike lines are great for the sides of his hair.

Form the full outline of the binding cloth before adding the horizontal lines on the inside.

Sketch out his torso and pants. His hands will eventually be in his pockets, so the lines forming his upper legs will actually be the pockets.

Draw his wrists emerging from his pockets, then his arms.

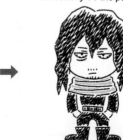

Think of his mask as a pair of rounded diamonds connected in the middle. Give him small pupils, plus three wrinkles in the center.

He can shoot the air he inhales from the ports on the soles of his feet, allowing him to maneuver quickly while attacking enemies.

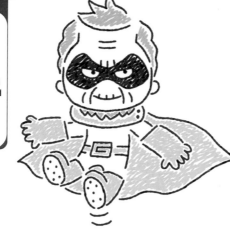

With strong ties to the One For All successors, Gran Torino was a mentor to All Might and trained Deku during the internship period. Ample wrinkles help to show how old he is.

IN COSTUME

DRAWING THE BODY

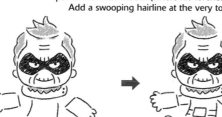

The outline of his face looks like an earthen pot with a wide mouth (where his forehead is). Add a swooping hairline at the very top.

Give him thick, short arms, and draw his torso at a slight angle.

Connect arms to torso. Draw the soles of his boots to make it look like he's floating.

Join his feet to his body.

After drawing his cape nice and wide, add some motion lines under one foot to create a floating effect.

Though calm and brainy, Nighteye also brings a sense of humor to the table. His support items (extremely weighty personal seals) are part of the joke, so don't forget to include one in your drawing.

ALL ABOUT THE EYES

Imagine dividing a hexagon in half, and you've got his glasses frames. His half-moon eyes fit entirely within the frames. Combine his skeptical eyebrows with his brow creases to create a little volcano shape.

EXPRESSION

DRAWING THE BODY

His hair is parted with a clean-cut 70:30 ratio.

Since you'll be adding color to his hair highlights in the next step, first draw their outlines—two almond shapes on the left, and one on the right.

Draw the torso as a thin upside-down triangle.

Add his raised left hand and one of his personal seals.

Draw his right hand pinching the seal from above and connect his arms to his torso.

Finally, the necktie is red with white polka-dots.

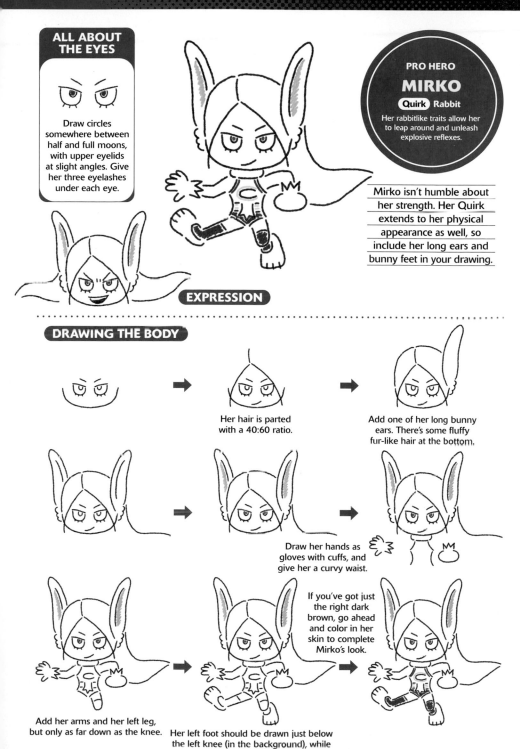

ALL ABOUT THE EYES

Draw circles somewhere between half and full moons, with upper eyelids at slight angles. Give her three eyelashes under each eye.

EXPRESSION

Mirko isn't humble about her strength. Her Quirk extends to her physical appearance as well, so include her long ears and bunny feet in your drawing.

DRAWING THE BODY

Her hair is parted with a 40:60 ratio.

Add one of her long bunny ears. There's some fluffy fur-like hair at the bottom.

Draw her hands as gloves with cuffs, and give her a curvy waist.

If you've got just the right dark brown, go ahead and color in her skin to complete Mirko's look.

Add her arms and her left leg, but only as far down as the knee.

Her left foot should be drawn just below the left knee (in the background), while her right leg can be extended in a kick.

SEVENTH USER OF ONE FOR ALL
NANA SHIMURA
Quirk One For All

Draw her pointer fingers tugging the corners of her mouth into a smile (with her beauty mark below her mouth). Then draw her bangs.

The hair behind her head is tied up in a spiky bundle, with a small bun on the far-right side.

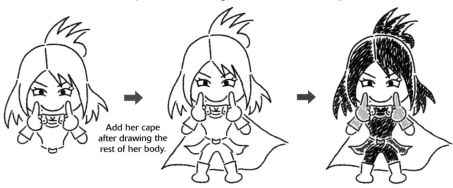

Add her cape after drawing the rest of her body.

 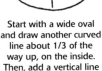

Start with a wide oval and draw another curved line about 1/3 of the way up, on the inside. Then, add a vertical line right in the middle, at the bottom.

Using that first tooth line as a guidepost, fill in the rest of the teeth to the left and right.

PRO HERO
FAT GUM
Quirk Fat Absorption

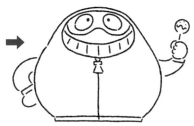

His body should be shaped like a wide pear. Then add the arms and hands.

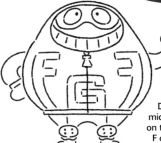 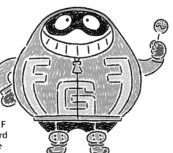

Draw a large G in the middle of his tummy, an F on the left, and a backward F on the right. Finish the drawing with his legs.

Start with his head, which is a combination of a rounded forehead and a dorsal fin. With this side view his eye should almost look like a quill pen.

After drawing his button-up shirt's collar and his rounded pectoral fin (draped over his shoulder), fill in the sharp teeth.

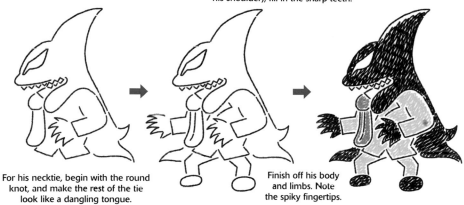

For his necktie, begin with the round knot, and make the rest of the tie look like a dangling tongue.

Finish off his body and limbs. Note the spiky fingertips.

His sunglasses should slant toward the upper right. Next come his headphones, along with the speaker around his neck. Imagine the speaker as a partially opened book with a very thick spine, as viewed from behind.

Draw his hair like the end of a broom, with thin, spiky tufts.

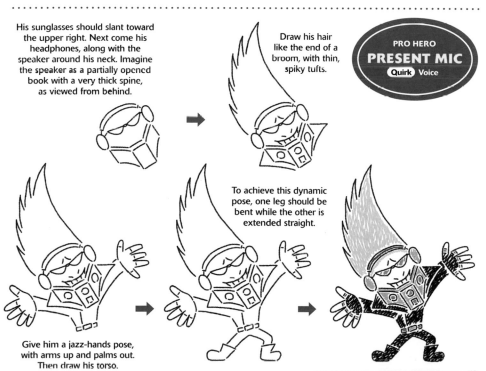

To achieve this dynamic pose, one leg should be bent while the other is extended straight.

Give him a jazz-hands pose, with arms up and palms out. Then draw his torso.

PRO HERO
THIRTEEN
Quirk Black Hole

Draw a half-moon for her helmet, and large round eyes that are flat at the bottom.

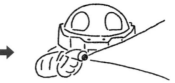

For the black hole suction effect, start with a giant less-than sign (<) emerging from her fingertip. Then, draw the right hand and arm.

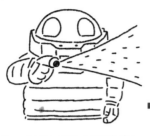

To make the space suit look nice and puffy, start with a bunch of horizontal lines and connect them with a series of rolling hills.

Her ankles are surprisingly skinny.

When coloring in the suction effect, start at the wide end and make your blotches of color condense toward her fingertip!

PRO HERO
PRINCIPAL NEZU
Quirk High Specs

Start with a rounded trapezoid for his head. Add a long vertical scar over his right eye.

The rest of his body looks like an upside-down copy of his head. Draw a large V at his collar and a small upside-down V at the bottom of his vest.

The tiny paw pads on his outstretched hand are extremely important!

Make his tail nice and long.

ALL ABOUT THE EYES

His eyes are angled slightly inward. He's got a scar over his right eye and crinkly wrinkles surrounding both eyes.

EXPRESSION

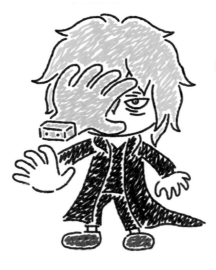

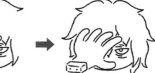

VILLAIN
TOMURA SHIGARAKI

Quirk Decay

Anything he touches with all five fingers (including people) crumbles away to nothing.

As the leader of the League of Villains, he seeks to destroy the world. The hands stuck to Shigaraki's body once belonged to the family members he killed. If nothing else, your drawing should show how skin-crawlingly creepy he is.

DRAWING THE BODY

Begin with the hand that's attached to his face.

Draw one eye peeking out from behind the hand and add his curved jawline.

The hair should be somewhat wavy.

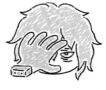

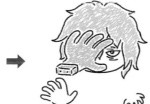

His right palm is thrusting forward, so draw it bigger than usual.

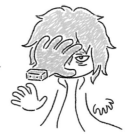

Draw the front of his long, open coat.

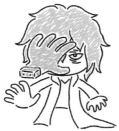 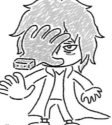 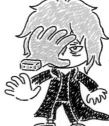

Connect his arms to his torso, add a line separating shirt from pants, and finish by drawing his pants and shoes.

VILLAIN

ALL FOR ONE

Quirk All For One

The power to steal the Quirks of others and give them away. Stolen Quirks can be stocked up, allowing him to use several at once.

This person manipulates the League of Villains from the shadows. All For One needs to wear a life-support mask because of injuries dealt to him in a past battle. The mask can be tricky to draw, but try not to skimp on the details.

ALL ABOUT THE EYES

Each eye looks like a flower petal with two horizontal lines inside. He's got four wrinkles on his brow, above his eyes.

EXPRESSION

DRAWING THE BODY

Start with four triangles.

Draw the outline of his head, then his eyes and wrinkles.

For the mask, start with a long rectangle coming down from where his nose would be, and add lines coming down from his ears, spreading slightly wider as they go.

The pipes of the mask wrap all around his neck.

His torso is a large upside-down triangle.

To complete that powerful image, draw his arms spread wide from just under the life-support mask.

ALL ABOUT THE EYES

His eyes are slightly thinner than half circles, with short upper eyelids and straight eyebrows. Add those half circles underneath, complete with the rows of stitches.

For the burn scars, thin dotted lines make it look like wrinkled, mottled skin.

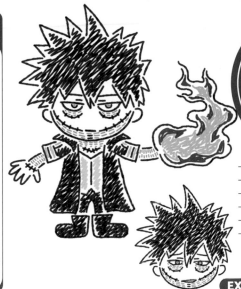

VILLAIN
DABI

Quirk ? ? ?

A heat-based Quirk that allows him to shoot high-powered blue flames from his palms.

Despite his fiery Quirk, Dabi's body isn't so hot at taking the heat. Be sure to draw thin dotted lines to represent his burn scars.

EXPRESSION

DRAWING THE BODY

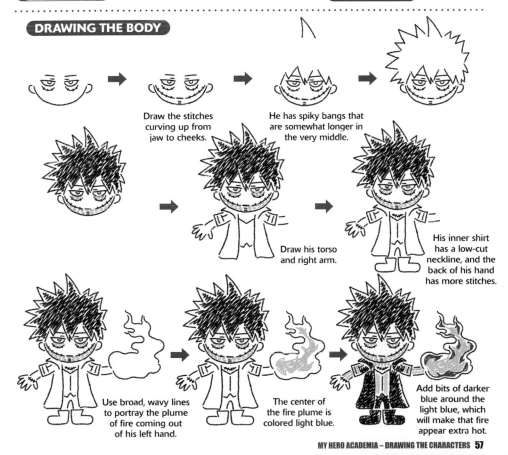

Draw the stitches curving up from jaw to cheeks.

He has spiky bangs that are somewhat longer in the very middle.

Draw his torso and right arm.

His inner shirt has a low-cut neckline, and the back of his hand has more stitches.

Use broad, wavy lines to portray the plume of fire coming out of his left hand.

The center of the fire plume is colored light blue.

Add bits of darker blue around the light blue, which will make that fire appear extra hot.

VILLAIN

HIMIKO TOGA

Quirk Transform

Allows her to transform into another person by drinking their blood. Sometimes she can also use the target's Quirk.

Toga is obsessed with the blood of people she feels affection toward. Unfortunately, she expresses her love in unconventional ways and ends up hurting people. Those sharp teeth aren't actually long fangs—they're just canine teeth that stick out.

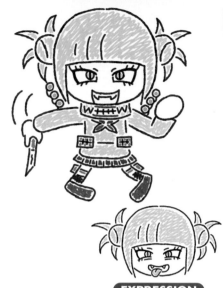

ALL ABOUT THE EYES

Her eyes are curved trapezoids with shorter lines on the inside and longer lines on the outside. There are vertical-slit pupils inside her irises. Draw her upper eyelids as short lines lined up with the inner corners of her eyes, and don't forget to add eyelashes on the top and bottom.

EXPRESSION

DRAWING THE BODY

Those straight-cut bangs are distinctive! Be sure to include her especially sharp teeth.

Draw her overall hairstyle as a big round bob, with a bun on each side.

Add messy tufts of hair sticking out in random directions from each bun.

Add the equipment around her neck, and then her hands, arms, and torso.

Fill in the teeth-like pattern on the equipment around her neck, and add the front-facing syringes above each shoulder. The lower hem of her cardigan should be rounded and baggy. Give her a knife to hold too.

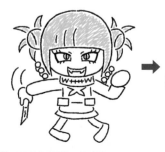

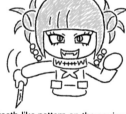

Draw her legs flipping out to the sides, with her pigeon-toed feet pointing inward. The skirt should be pretty short.

He's got large eyes underneath a swooping brow line. The creases in the center are basically extensions of the lines forming his eyes.

EXPRESSION

VILLAIN

TWICE

Quirk Double

Given enough data, he can make a perfect copy of anyone or anything. If he makes a double of himself, that new double can go on to create another double.

When a gang of his own doubles rebelled, Twice's sense of self crumbled, leading to split personalities. The mask is how he keeps the split personalities in check. By the way, he's not bald—the costume mask is just tight!

DRAWING THE BODY

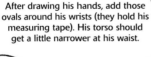

His head is an oval, slightly taller than it is wide. Draw his brow line right around the middle, with one side curving up skeptically.

Add his eyes.

The part of the mask covering the lower half of his face curves up where it hits his nose.

After drawing his hands, add those ovals around his wrists (they hold his measuring tape). His torso should get a little narrower at his waist.

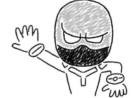

Add a Y-shaped symbol on his chest.

Overhaul is obsessive about cleanliness, so he wears the plague-doctor mask and only removes his gloves to use his Quirk (which he must do bare-handed). Make that mask bold and flashy!

ALL ABOUT THE EYES

His eyes are upside-down triangles that slope inward, with two lower eyelashes on each. The eyebrows should be at the same angle as the eyes and have little kinks (that make them look like lightning bolts) 2/3 of the way up from the bottom.

EXPRESSION

. .

DRAWING THE BODY

 → → →

In these early steps, the plague-doctor mask will look like a bird's beak.

After drawing the eyes, add his jawline (emerging around the middle of the mask) and ears.

Make sure the mask straps appear to loop around his ears. Next, add his short bangs and the tufts of hair on the very top of his head.

His hair should be relatively short all around.

 → →

Draw his feathery jacket collar. When drawing his gloves, add that extra line where each glove meets his wrist.

 → →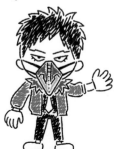

The jacket bulges a little bit at the very bottom.

ALL ABOUT THE EYES

Triangles form his thin eyes. The eyebrows should slope down at an extreme angle, and they have thin outer tips.

IN COSTUME

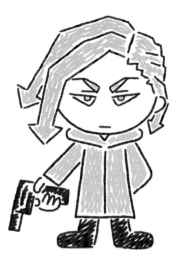

VILLAIN
CHRONOSTASIS
Quirk Chronostasis

His locks of hair (which resemble clock hands) can stretch out and stab targets to slow down or freeze them.

As Overhaul's trusted confidant since childhood, Chronostasis is a strong backer of Overhaul's plans. He's got a handsome, clean-cut face under his mask. If nothing else, make sure to draw his hair right!

DRAWING THE BODY

Start with his jawline, then draw an angled lock of hair coming down from the center of his forehead.

Make that main forelock look like a giant arrow, and draw another arrow tucked behind his ear on the other side.

Draw the rest of his arrow-like hair.

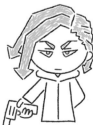 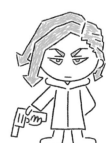 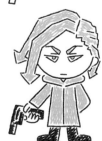

His torso should be pretty thin, with a clean, straight coat. Don't forget the hood.

His head is shaped like a lima bean with a big crack in it. Next, draw his eyes, including the creases around them.

VILLAIN
STAIN
Quirk Bloodcurdle

Draw his fiery-looking hair. That long tongue should stick out to the side, beneath his upper jaw.

Make his lower jaw come to a sharp point. His left hand is holding a survival knife, while his right has a katana.

Draw some cloth wrapped around his neck, with pieces of the fabric fluttering off to either side around eye level and above his head. To make the fabric look damaged, imagine that you're drawing long, skinny bat wings.

Draw his lower legs, from knee to toe, before adding his butt between his knees, and finally his torso. This captures him in a leaping pose!

His side profile resembles a beaked bird, if that bird had cloth wrapped around its eyes.

VILLAIN
SPINNER
Quirk Gecko

He wears his eye mask on his forehead. Make the bulk of his hair flip backward, with the tips flipping out at different angles.

Next, draw the scarf wrapped around his neck, as well as his left hand, which is holding a katana.

Draw his arms with stripes to represent the wrapped cloth, and give claws to the hand not holding the sword.

The blue polka dots on his top are essential.

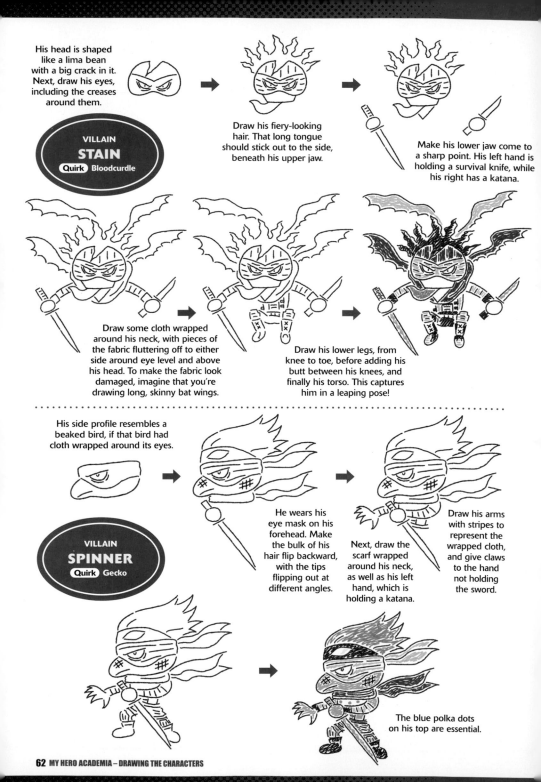

The lines forming his chin guard almost look like a pair of chairs facing each other.

Draw the outline of his head with wibbly-wobbly lines. The very top should have randomly placed lines floating away, like steam. Finally, the upper lines of his eyes should be straight and long, shooting down at a steep angle.

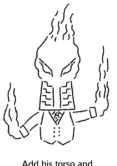 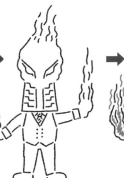 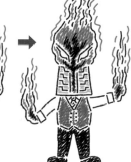

Add his torso and arms next, with more of that steam-like substance emerging from his hands.

After filling in his head and hands with purple, add some black to the deepest parts of each section. You want your Kurogiri to look good and scary!

Imagine an egg wearing a hat. Add the horizontal lines for the mouth on the mask, and then a vertical line in the middle, at the bottom.

That previous vertical line is your center line. Draw the mask's eyes and teeth on either side.

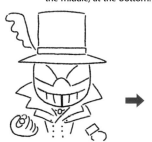 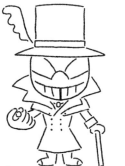

Next comes the giant collar of his coat, along with his right hand, which is holding two compressed marbles. Draw his left wrist and part of his left hand.

Finish by drawing the rest of his coat, his boots, and a cane placed in that partially drawn left hand.

Izuku Midoriya

Katsuki Bakugo

Shoto Todoroki

Ochaco Uraraka

Tenya Ida

Tsuyu Asui

Eijiro Kirishima

Momo Yaoyorozu

Fumikage Tokoyami

Minoru Mineta

Denki Kaminari

Kyoka Jiro

Hanta Sero

Yuga Aoyama

Mina Ashido

Mezo Shoji

Mashirao Ojiro

Toru Hagakure

Rikido Sato

Koji Koda

Tetsutetsu Tetsutetsu

Neito Monoma

Itsuka Kendo

Mirio Togata

Tamaki Amajiki

Nejire Hado

Hitoshi Shinso

Mei Hatsume

Yo Shindo

Eri

All Might (M)

All Might (T)

Endeavor

Hawks

Best Jeanist

Eraser Head

Gran Torino

Sir Nighteye

Mirko

Tomura Shigaraki

All For One

Dabi

Himiko Toga

Twice

Overhaul

Chronostasis

CAN YOU DRAW THEIR EYES? YES? THEN YOU'RE OFF TO A GOOD START!

THINK YOU'VE MASTERED THE BASICS? THIS NEXT SECTION KICKS THE DIFFICULTY UP A NOTCH!

PLUS ULTRA!!

2

MIX-AND-MATCH COMBOS

DEKU & BAKUGO
(RIVAL SPIRITS)

Draw Bakugo in front, since it should look like he's one step ahead of Deku.

Start with Bakugo's face, since he's walking in front.

Draw Deku's face behind Bakugo's, with a little bit of overlap.

Next come their torsos and arms.

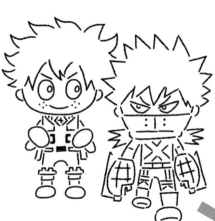

Make sure Bakugo's left foot is bigger, as if he's taking another step forward.

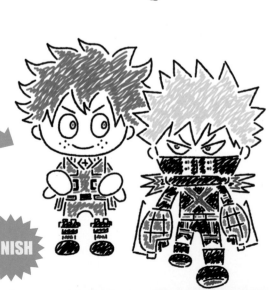

FINISH

DEKU & BAKUGO & TODOROKI
(WORK-STUDY TRIO)

Their different facial expressions
are key to this composition!

Begin by drawing
Todoroki's head, since he'll
be in the very middle.

Deku and Bakugo's heads
come next. Todoroki's head
should overlap them slightly.

Add in the bodies next.
Note that Bakugo's blazer
is unbuttoned. Deku's
necktie should look extra
short and just a little
curled to one side.

Bakugo lets his pants
hang low, so place his belt
appropriately and make
his pant cuffs look baggy
and wrinkled. On the other
hand, Deku's cuffs are
tucked into his shoes.

FINISH

DEKU & BAKUGO
& TODOROKI
(DUKING IT OUT)

This scene will be easiest if you draw
Todoroki, then Bakugo, then Deku.

Since Todoroki is swinging his
left arm and using his fire, draw
his arm below his head. Only
part of the arm is visible, since
the rest is hidden by fire.

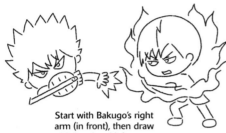

Start with Bakugo's right
arm (in front), then draw
his head and left arm.

Since Deku is facing
downward, his hair should
take up a lot more space
than his face.

Draw Deku's
stretched legs
popping out
to either side,
behind his arms.

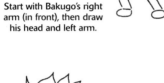

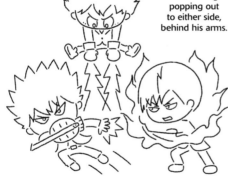

Bakugo is leaping to the left, so
draw his body on the diagonal,
at the same angle as his motion.
His right leg should be bent.
Adding motion lines gives the
illusion of movement and speed.

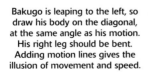

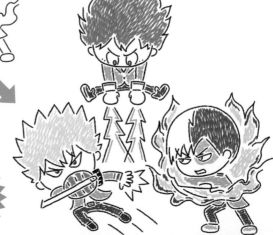

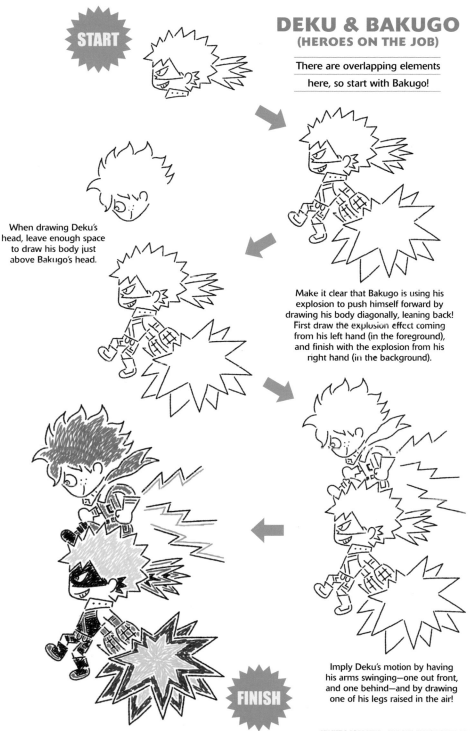

START

DEKU & BAKUGO
(HEROES ON THE JOB)

There are overlapping elements here, so start with Bakugo!

When drawing Deku's head, leave enough space to draw his body just above Bakugo's head.

Make it clear that Bakugo is using his explosion to push himself forward by drawing his body diagonally, leaning back! First draw the explosion effect coming from his left hand (in the foreground), and finish with the explosion from his right hand (in the background).

Imply Deku's motion by having his arms swinging—one out front, and one behind—and by drawing one of his legs raised in the air!

FINISH

THE GIRLS IN SCHOOL UNIFORMS

Summer uniform, winter uniform, and in-between uniform! Try to master drawing all the types!

START

Start with Jiro in the middle, overlapping Ashido's and Ochaco's heads.

Draw Jiro's body first. Her vest has a V at the top and a W at the bottom. For the jacket of Ochaco's winter uniform, make the waist curve in slightly.

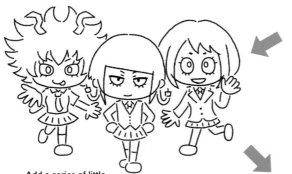

Add a series of little lines to make the pleats of their skirts. Ochaco's winter uniform uses tights, not socks.

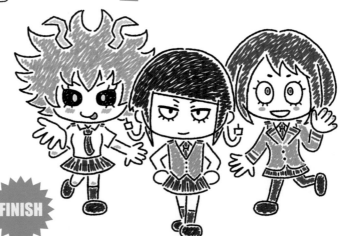

FINISH

OCHACO & TSUYU & MOMOYAO
(HEROES ON THE JOB)

START

Getting the overall balance right can be tricky, so start with Ochaco.

Don't draw all of Tsuyu's tongue just yet. This is important!

After drawing Tsuyu's very large hands, add her torso too.

Draw Ochaco's right boot larger than normal to show that she's stepping forward. Her left leg is meant to be bent, so draw it jutting out to the side from the knee down.

Finish drawing Tsuyu's tongue, slightly thicker near the tip, without overlapping with her hand. Consider the balance of the whole scene before finishing with Momoyao's cape.

FINISH

KIRISHIMA & TETSUTETSU
(CARBON COPY COMBO?)

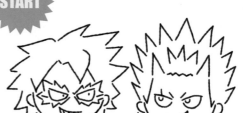

START

Because they'll be clasping hands in the middle, draw their heads spaced apart a little.

Draw the boys' heads, without them overlapping.

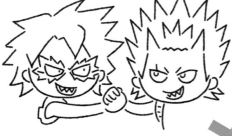

Add their clasping hands in the middle. Since Kirishima's hand is on top, draw his fingers.

A spiky action effect under their hands can imply the loud smack as their hands come together.

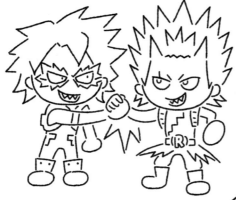

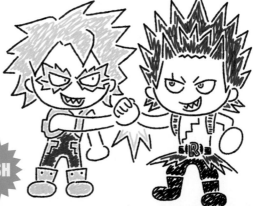

FINISH

3

SKETCHES FOR INSPIRATION

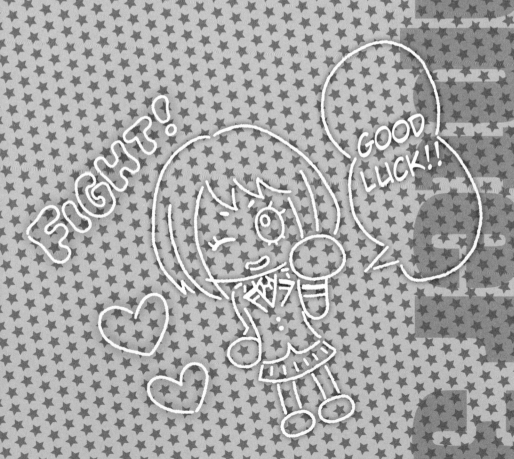

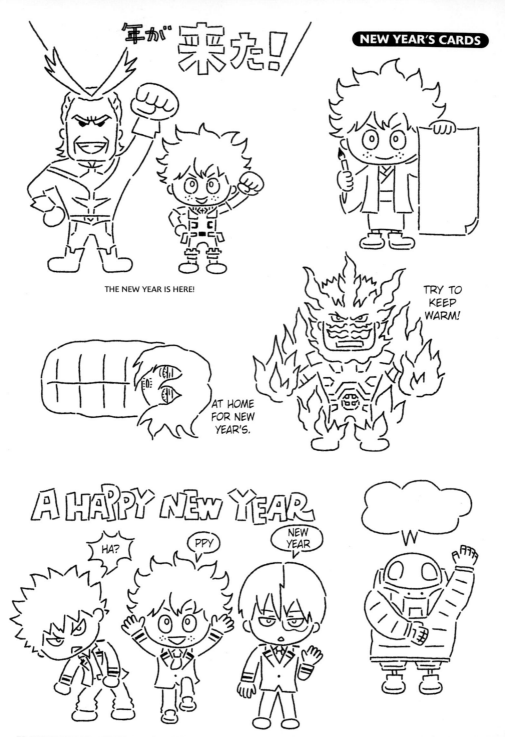

BIRTHDAY

HAPPY BIRTHDAY!

HAPPY BIRTHDAY DEAR

HAPPY BIRTHDAY

HAPPY BIRTHDAY

HAPPY BIRTHDAY!

HAPPY BIRTHDAY DEAR

SUMMER

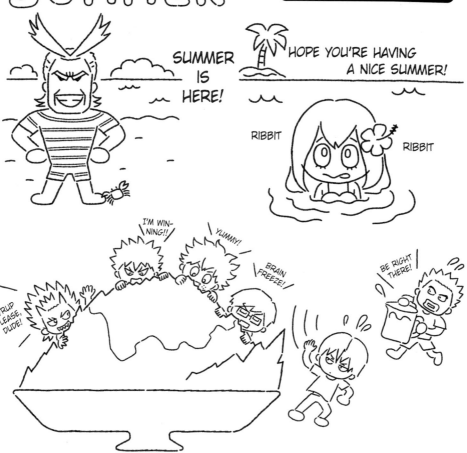

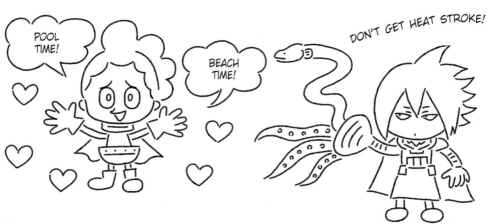

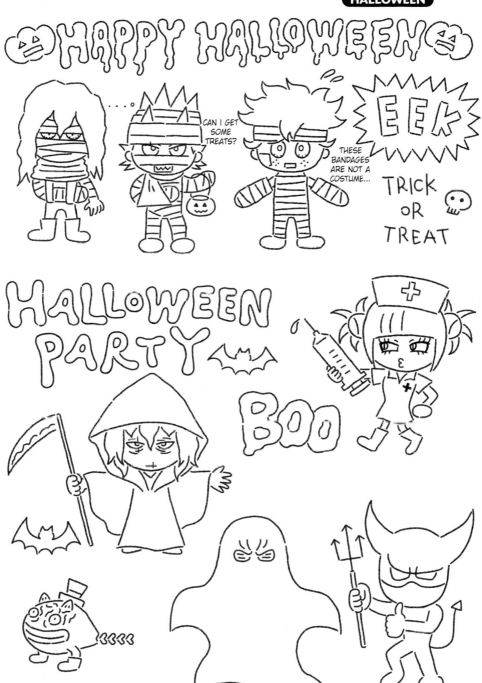

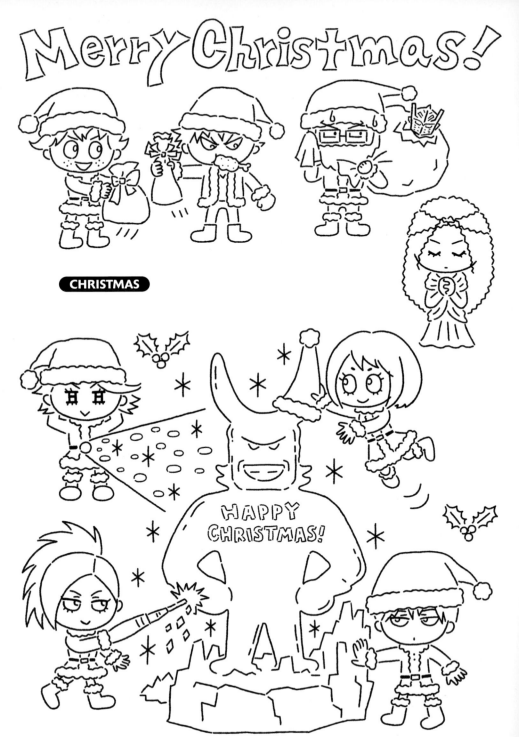

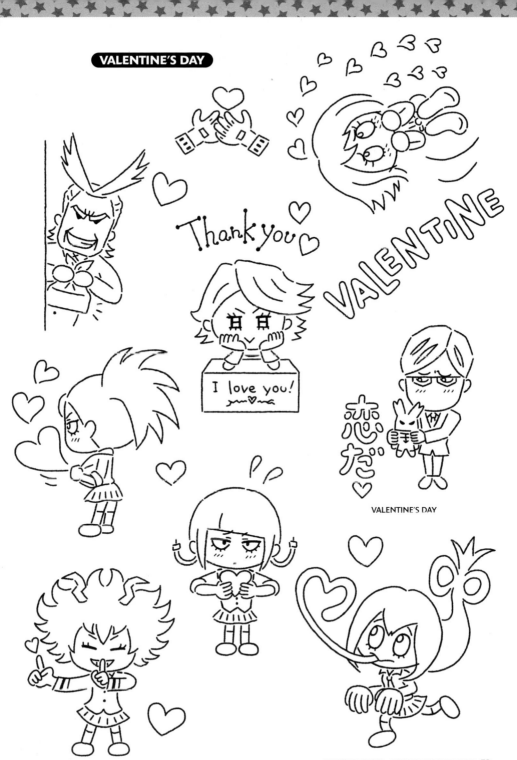

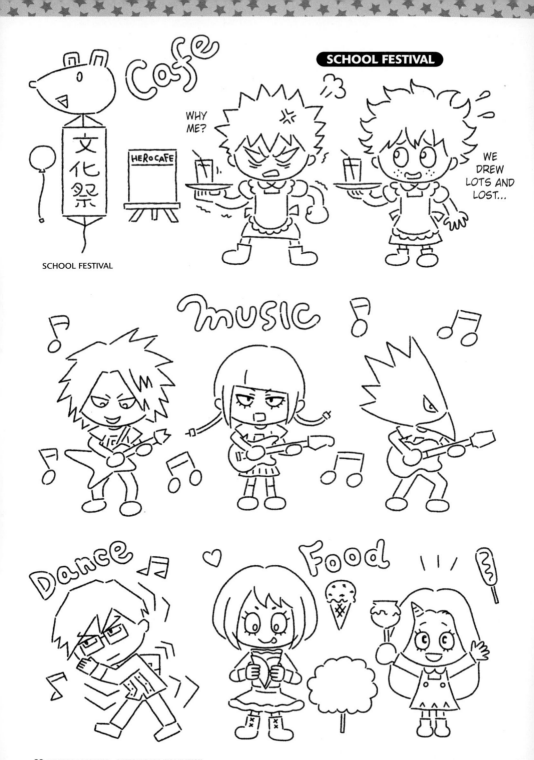

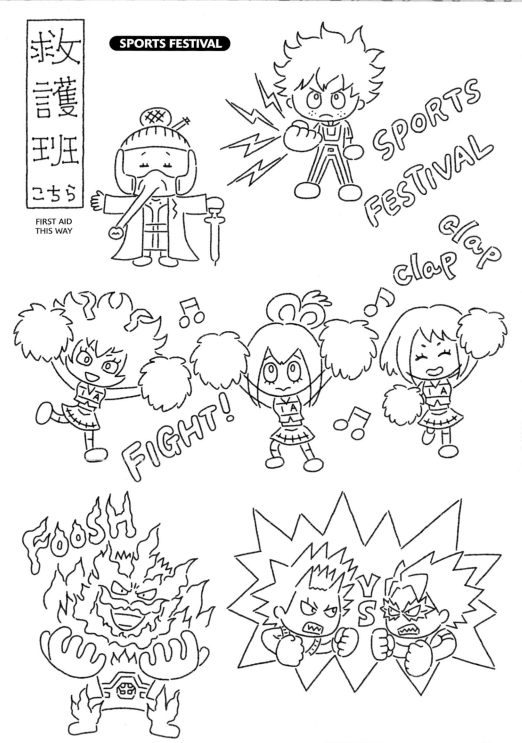

救護班こちら

FIRST AID
THIS WAY

SPORTS FESTIVAL

SPORTS FESTIVAL

♪ CLAP CLAP

FIGHT!

FOOSH

VS

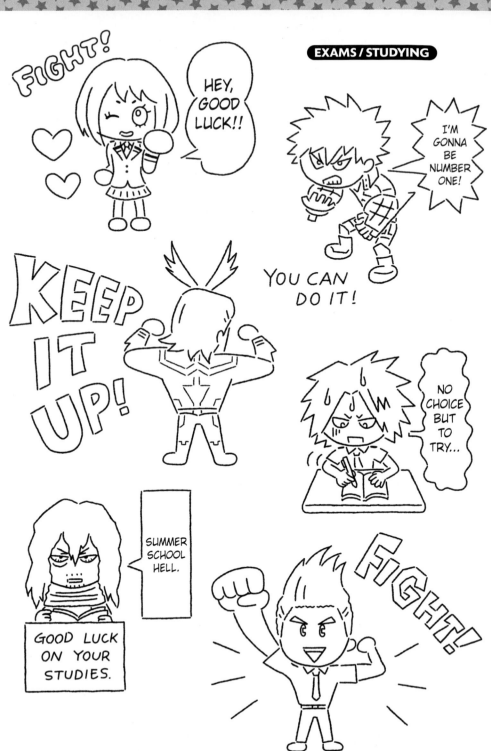

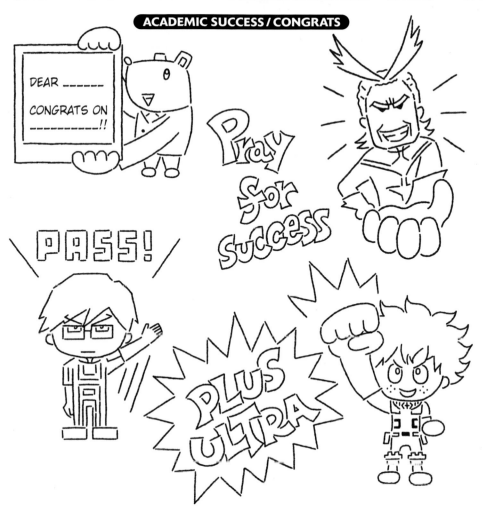

CONGRATULATIONS ON PASSING!

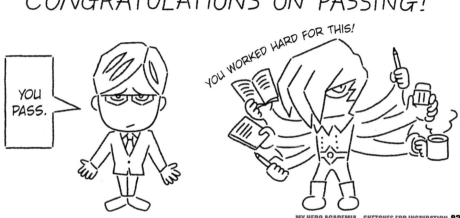

I AM HERE!
DADOOM

I'M NOT GONNA LOSE.

I'M GETTING DRY EYE OVER HERE.

WAHHHHH!

HANG. IN. THERE.

YAYYY!

HA HA HA

NON, NON. NOT SHINY...

TWINKLY!

UHHH?!

SORRY!

IT'S ABOUT MY PRIDE.

I WANNA GO...

FRAMES AND BORDERS

MUTTERMUTTERMUTTER

THANK YOU.

SMASH!!

OH!

GLOOP

CLAPCLAP

BOOO

BOOOM

BOM

CRACK

HAHAHA

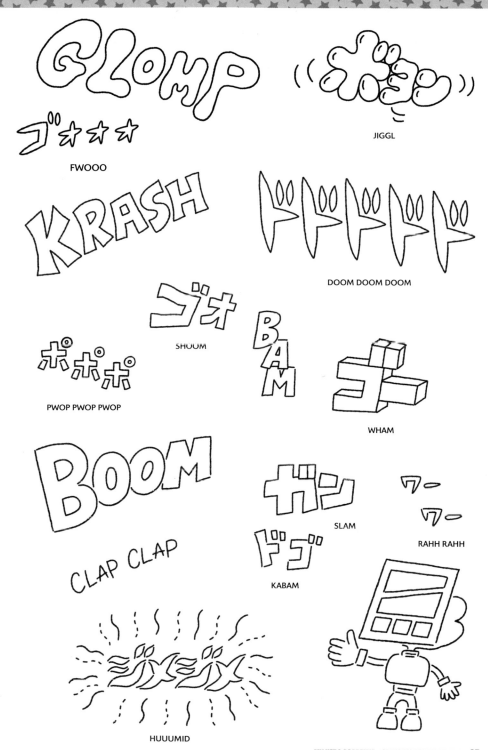

GLOMP

ブ゚☆☆☆

FWOOO

JIGGL

KRASH

DOOM DOOM DOOM

SHUUM

ポポポ

PWOP PWOP PWOP

BAM

WHAM

BooM

SLAM

RAHH RAHH

CLAP CLAP

KABAM

HUUUMID

MY HERO ACADEMIA

THE OFFICIAL EASY ILLUSTRATION GUIDE

Original Series by **KOHEI HORIKOSHI**
Illustrations by **MIKA FUJISAWA**

SHONEN JUMP EDITION

Translator **CALEB COOK**
Designer **FRANCESCA TRUMAN**
Editor **DAVID BROTHERS**

JAPANESE EDITION

Original series **KOHEI HORIKOSHI**
Illustration **MIKA FUJISAWA**
Layout/editing (Original Edition) **HISAKO TOKUNOU**
Design (Original Edition) **TAKESHI IWASAWA (DESIGN ROCK)**
Publisher (Original Edition) **TORU KIYOMIYA**
Publishing house (Original Edition) **HOME-SHA, INC.**
Distributor (Original Edition) **SHUEISHA INC.**

**BALL-PEN DE KAKERU! BOKU NO HERO ACADEMIA
KANTAN ILLUST GUIDE**
© 2021 by Kohei Horikoshi, Mika Fujisawa
All rights reserved.
First published in Japan in 2021 by SHUEISHA Inc., Tokyo.
English translation rights arranged by SHUEISHA Inc.

Library of Congress Control Number: 2023934641

Published by **VIZ MEDIA, LLC**
P.O. Box 77010 | San Francisco, CA 94107

ISBN: 978-1-9747-4036-9
Printed in China

10 9 8 7 6 5 4 3 2 1
First printing, October 2023

viz.com